The Art of Glass from Gallé to Chihuly Highlights from the Lowenbach Collection

A PROMISED GIFT TO THE NEWARK MUSEUM

THE NEWARK MUSEUM

ACKNOWLEDGEMENTS

In nearly twenty-seven years as Curator of Decorative Arts at The Newark Museum, I have never stopped learning new things. Researching studio glass for this project has been tremendously rewarding, because it has allowed me to delve more deeply into a topic about which I have known a little bit for a long time. Contemporary ceramics has drawn a lot of my attention over the years, because of the Museum's rich tradition of modern ceramics. Being able to focus on the parallel growth of the studio glass movement, and to place it in the context of our twentieth-century glass collection, has been a joy. None of this, of course, would have been possible without Dena and Ralph Lowenbach's encouragement and support. Their faith in this Museum and its mission is gratifying, and I look forward to our ongoing collaboration.

There are many other people to thank. Perry Price, my bright and diligent research intern from the Coopers-town Graduate Program, got my brain jumpstarted and helped me forge the curatorial voice that shaped this exhibition. Rick Randall, our talented exhibition designer, produced the elegant and coherent installation to highlight the wildly diverse objects I have chosen to showcase. Eva Heyd, who came all the way from the Czech Republic, made stunningly beautiful images of the contemporary glass for this book, and Richard Goodbody added to this with his own beautiful photographs. Marc Zaref designed the book itself as a beautiful and permanent reminder of this landmark exhibition. From the Museum's staff, I am so grateful to Alison Edwards and Michael Schumacher, for shepherding me and my project through the complex process of realization; to Batja Bell for her tireless attention to detail in caring for and transporting the artworks in the exhibition. I also wish to express my gratitude to Prudential Financial, The Newark Museum Volunteer Organization, and the Art Alliance for Contemporary Glass for their invaluable support of this project.

Finally, my thanks go to our director, Mary Sue Sweeney Price, for backing me all the way. She has watched my curatorial vision develop over twenty-seven years, and she immediately recognized how this project would be a tremendous way to approach the Museum's 100th anniversary.

—Ulysses Grant Dietz, *Curator of Decorative Arts*

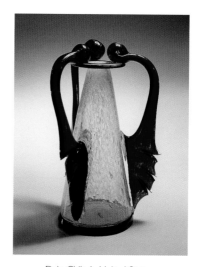

Dale Chihuly, United States,
Blue Venetian, 1988, 20 × 13 × 13 in.,
Collection of The Prudential Insurance
Company of America

FOREWORD

The Art of Glass from Gallé to Chihuly is an historic milestone for The Newark Museum. For the first time we are able to present a sweeping survey that explores the evolving concept of glass as an artistic medium in the twentieth century. At the same time, we celebrate an unparalleled promised gift of contemporary studio glass that will forever transform our collection. When Dena and Ralph Lowenbach first approached us regarding the possibility of leaving their contemporary glass collection to the Museum, Curator of Decorative Arts, Ulysses Grant Dietz, the Museum's trustees and I were thrilled. Almost immediately after our first conversation with the Lowenbachs, Ulysses Dietz conceived of this exhibition, which would give us an opportunity to integrate their contemporary works with our own historic holdings of art glass and early studio glass.

The Newark Museum's interest in glass as art dates back to groundbreaking exhibitions of *Modern German Applied Arts* in 1912 and 1922. As early as 1913, we purchased our first pieces of glass designed by Otto Prutscher and René Lalique, establishing a tradition that has continued ever since. Although our glass collection is large and comprehensive, it is not without significant gaps. The visionary purchases made by founding director, John Cotton Dana, and the curators who followed him were immeasurably enhanced by two significant gifts from earlier New Jersey collectors. Between 1966 and 1967, Mr. and Mrs. Ethan Alyea of Montclair gave a group of over forty pieces of

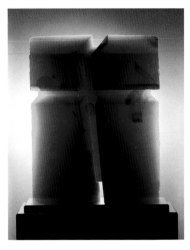

Stanislav Libensky and Jaroslava Brychtova,
Czech Republic, *Cross Composition*, 1986,
Gift of Dena and Ralph Lowenbach, 2006
Collection of The Newark Museum

American and French art glass. In 1996, Dr. and Mrs. Jerry Raphael of Clifton gave nineteen examples of early American studio glass from the formative years of the movement, several of which appear in this exhibition.

It is the promise of the Lowenbach Collection, however, that allows the Museum to make the great leap, to build upon the rich foundation established during our ninety-eight year history, and to present the aesthetic and technical range of contemporary studio glass across the globe as it stands at the beginning of the twenty-first century. As the Museum approaches its centennial year in 2009, we enter into our relationship with the Dena and Ralph Lowenbach and move forward in this partnership with a heightened sense that together we are making museum history.

The Trustees and I thank the special supporters of this exhibition, Prudential Financial, The Newark Museum Volunteer Organization, and the Art Alliance for Contemporary Glass. As always The Newark Museum is grateful to the City of Newark, the State of New Jersey and the New Jersey State Council on the Arts/Department of State, for annual operating funding that makes possible all we do.

—Mary Sue Sweeney Price, *Director*

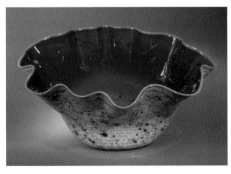

Dale Chihuly, United States, *Permanent
Blue Macchia with Cadmium Orange Lip Wrap*, 1986,
Purchase 1988 The Members' Fund
Collection of The Newark Museum

We never set out to be collectors. From the beginning of our marriage, when our budget would permit, we acquired modern painting and bronze and stone sculpture in order to make our home environment pleasing to us. Twenty-five years later, after several visits to a gallery which carried only glass sculpture, we bought our first two pieces. The fact that they were made of glass was irrelevant to our decision to acquire them, except that the unique characteristics of glass—translucency, refraction and transformation in changing light—gave the works a dimension of beauty which was exceptionally appealing. These first pieces fit with our other art. One was a vessel which depicted Stonehenge-like monoliths in a very painterly manner. The other was an abstract sculpture. Shortly thereafter, we were invited by the gallery to join a group of collectors of glass art for a weekend in the Berkshires, where we went to collectors' homes and visited artists who worked in glass. We realized for the first time the incredible variety of artistic expression which the use of glass makes possible.

We have built our collection over the past twenty years on the basis of our own artistic sensibilities. There is no underlying theme except that we sought to acquire pieces which are excellent examples of the artist's body of work. We do not focus on any particular artist, but look for pieces which appeal to us aesthetically, regardless of the style or reputation of the artist. In fact, we always look to acquire work by artists who are not yet widely known. Such work is frequently characterized by refreshing originality.

Our collecting activities have enabled us to make friends around the world who are collectors or gallery owners. Because contemporary glass sculpture is a young art form, we have been able to meet and spend time with many of the artists. These personal benefits, not apparent if the collection is viewed in isolation, have been extremely important and gratifying to us.

Our decision to leave our collection to The Newark Museum was based on our life-long and continuing connections to the city of Newark, our respect and admiration for the Museum, and our conviction that the arts are an important catalyst in the revitalization of the city.

—Dena and Ralph Lowenbach, *April 2007*

Marc Zaref

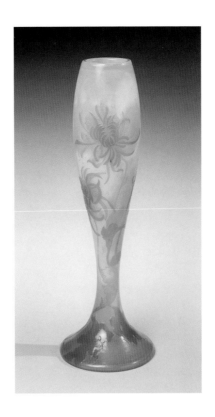

ART GLASS AT THE NEWARK MUSEUM

ULYSSES GRANT DIETZ

When The Newark Museum's founding director, John Cotton Dana, purchased an "old" carved glass vase by French artist Emile Gallé in 1921, it was part of a large group of Japanese objects that he was acquiring for his young institution. The Museum paid $2.50 for the vase, probably made around 1900 at Gallé's glass factory, la Cristallerie de Nancy. (Fig. 1) Dana, a "Japanophile," would have immediately discerned the Japanese influence on this vase, with its egg-yolk yellow chrysanthemums in low relief. In it Gallé has combined the styles of the aesthetic movement and art nouveau, both of which were indebted to Japanese design. But he would also have known of Gallé's technical innovation in the use of acid carving on blown and cased (layered) glass blanks. The process by which his new acquisition was created would have been as interesting to Dana as its aesthetic roots. Throughout Dana's career, he was driven to explore the concept that there was art in every object, due to the eye of the designer or the hand of the craftsman. Irritated by the hegemony of painting and sculpture in the art world, Dana looked to the applied arts, which he felt were more readily accessible to the average American.

Fig 1. Emile Gallé, France, *Vase with design of chrysanthemums*, ca. 1900, Purchase 1921
Collection of The Newark Museum

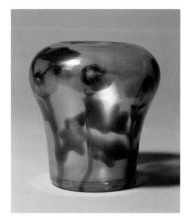

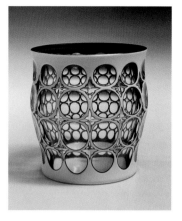

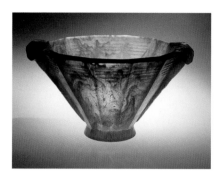

Fig 2. Louis Comfort Tiffany, United States, *Vase with internal decoration of poppies*, 1906-12, Gift of Mr. and Mrs. Ethan D. Alyea, 1966 Collection of The Newark Museum

Fig 3. Johann Oertel and Company, Bohemia (Czech Republic), *Cased and cut glass vase with design of circles*, 1922, Purchase 1923, Gift of Otto Kahn Collection of The Newark Museum

Fig 4. François Décorchemont, France, *Bowl of cast glass with low relief decoration*, 1928, Purchase 1929 Collection of The Newark Museum

Aside from Gallé, the other globally important figure in early twentieth-century glass art that intrigued Dana was Louis Comfort Tiffany. Like his French peer, Tiffany was not a glass-blower, but an artist who surrounded himself with people who knew the chemistry and technical aspects of glassmaking. Tiffany drove his blowers and gaffers to push the envelope and to create glass objects that were works of art, even if they happened to be functional. Aside from experimenting with ways to produce the iridescent surfaces found on long-buried ancient glass, Tiffany had his team explore a huge range of hot and cold techniques for forming and decorating his vessels. The two Tiffany glass pieces purchased by Dana in 1927 were deaccessioned during the dark days of Tiffany's disfavor. This loss, however, was more than made up for by the splendid gift of two dozen pieces of Tiffany glass from Mr. and Mrs. Ethan Alyea between 1966 and 1967. In particular, the internally decorated poppy vase produced by Tiffany's shop around 1910 exemplifies his mastery of a technique that would become crucial later in both Scandinavian art glass of the 1940s and 1950s, and also in studio glass of the 1980s. (Fig. 2)

The Museum's interest in glass-as-art carried on throughout the inter-war years, if not always consistently. Examples showcasing Scandinavian wheel-carving, Venetian *latticino* techniques—using colored glass threads, modernist Bohemian cased and cut glass and French *pâte de verre* cast glass were all acquired during the 1920s. Each of these pieces represents early efforts at art glass production in an industrial setting, as well as techniques that would reemerge in the studio glass movement of the 1960s. Oertel and Company, one of the chief producers in the Bohemian glass industry, worked within the celebrated Czech factory traditions of cased and wheel-carved glass, but produced striking modernist designs with these highly complex traditional techniques. (Fig. 3) François Décorchemont, trained as a potter, became one of the most important proponents of the cast *pâte de verre* technique—which uses ground glass power, capitalizing on his material's qualities of color and translucency. (Fig. 4)

In the years immediately after World War II, the Museum resumed acquiring art glass.

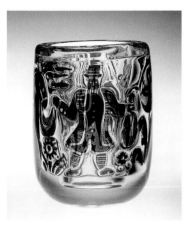

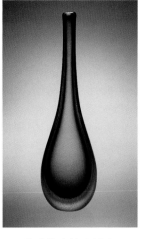

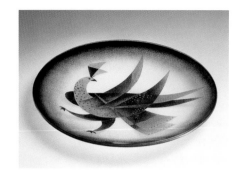

Fig 5. Edvin Ohrstrom, Sweden, *Vase of "Ariel" glass with internal decoration*, 1940-50, Gift of Miss Morna LaPierre, 1956 Collection of The Newark Museum

Fig 6. Paolo Venini, Italy, Bottle vase, *Notte*, 1958, Purchase 1958 Collection of The Newark Museum

Fig 7. Maurice Heaton, United States, *Plate with stylized bird design*, 1949, Purchase 1950 Collection of The Newark Museum

Scandinavian and Italian pieces were purchased through New York galleries, and the first examples of American proto-studio glass came into the collection directly from the artists. Edvin Ohrstrom and Sven Palmqvist captured America's eye with their "Ariel" and "Graal" lines of internally decorated glass for Orrefors in the 1940s and 1950s, even as Paolo Venini was bringing the ancient traditions of Murano into the modern era in his Venetian workshops. Ohrstrom's splendid "Ariel" vase from the 1940s, suggesting narrative content in a folksy modernist style, is a masterwork of Swedish factory-based art glass. (Fig. 5) In contrast, the subtly-hued *Notte* vase made in Venini's workshop in 1958 offers a minimalist antecedent to much contemporary studio work, from its softly layered colors to its discreetly carved surface. (Fig. 6) The factory-based glass work of Finnish artists Gunnel Nyman, Yrjo Rosola and Tapio Wirkkala were also part of the Museum's collecting strategy in the 1940s and 1950s, providing striking examples of blown, cast and wheel-carved glass. In particular, a carved leaf-form dish by Wirkkala from 1955, designed for the Iittala Glass Works, looks forward to the exploration of sculptural glass forms of the 1980s and 1990s.

The early advocates of American studio glass did not draw as much attention from the Museum's curators as their European counterparts did in the post-War years. The Museum did purchase three pieces from Maurice Heaton, who was among the first to apply enamel onto simple kiln-slumped forms. While Heaton made production-line pieces intended for household use, he also made painterly slumped vessels intended primarily as contemplative objects, very much in the *moderne* style of other craft artists of his period. His 1949 platter with a cubistic enameled bird is an iconic object of its time. (Fig. 7) Frances and Michael Higgins were studio glass pioneers of the 1950s and were also present at Harvey Littleton's landmark hot-glass workshops in Toledo in 1962. They exhibited their work at The Newark Museum during seasonal craft sales in the early 1950s, and the Museum purchased three examples of their layered and slumped glass. On the other hand, Glen Lukens, a potter-turned-glassmaker, who did early experiments in sandcasting and slumping, was entirely overlooked by the Museum, possibly because he was

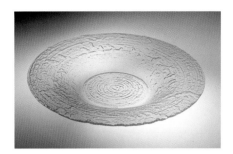 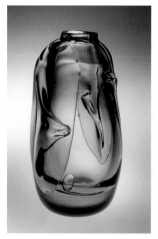 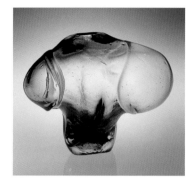

Fig 8. Glen Lukens, United States, *Slumped bowl/ platter, orange and black*, 1952-60, Purchase 1990 Estate of Clara Streissguth Collection of The Newark Museum

Fig 9. Dominic Labino, United States, *Vase of amber glass*, 1963, Gift of Dr. and Mrs. Jerry Raphael, 1996 Collection of The Newark Museum

Fig 10. Marvin Lipofsky, United States, *Vessel/sculpture of green glass*, 1965, Gift of Dr. and Mrs. Jerry Raphael, 1996 Collection of The Newark Museum

based on the West Coast. His black and orange slumped platter from the 1950s echoes his earlier ceramic work in its simple form and subtle approach to the colors and textures possible with cast glass. Even though it is technically a decorative arts object, Lukens' intent for this dish is purely sculptural, as it was with his pottery. (Fig. 8)

In the 1960s and 1970s, as the studio glass movement was taking shape in Toledo, in Seattle and in Europe, there was relatively little active collecting of any contemporary craft material at the Museum. A series of five decorative arts curators between 1961 and 1971, and a collecting emphasis on historical (i.e. old) objects was probably behind this shift in focus. Interestingly, however, the Museum purchased a blown glass piece by artist Roland Jahn in 1967, which directly echoes the work that Marvin Lipofsky and other glass artists of this generation were producing at the same time. Jahn, a student of Harvey Littleton, taught glassmaking in Philadelphia. The watershed for this kind of material came in 1996 with the gift of nineteen early works by studio glass artists of the 1960s and 1970s from Dr. and Mrs. Jerry Raphael. These historical examples provided a solid foundation upon which to build, and filled the gap left by collecting inactivity during that period. An early vase by Dominick Labino from 1963, made in the year following the first Toledo hot-glass workshops, for which he provided the technical expertise, demonstrates the tentative, experimental nature of this fledgling studio glass. (Fig. 9) Likewise, a piece from 1965 by Marvin Lipofsky typifies his work of this period, both in its intimate scale and in its attempt to create non-functional sculptural work with blown hot glass. (Fig. 10) As timid as these works seem in comparison with what would come later, they are the brave avant-garde of a movement just being born. That they would eventually be overwhelmed by their descendants, both in technical prowess and in artistic power, in no way lessens their significance as progenitors of an enormous artistic phenomenon.

In the 1980s and 1990s, the Museum did acquire some key pieces of contemporary studio glass, including works by Mark Peiser, Richard Marquis, Dale Chihuly and Toots Zynsky. Peiser's vase from 1976,

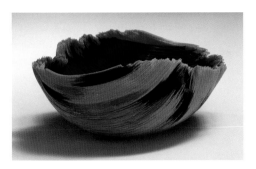

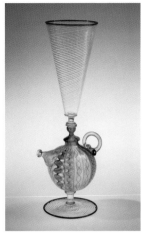

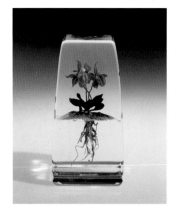

Fig 11. Toots Zynsky, United States, *Tierra del Fuego*, 1989, Purchase 1989 Thomas L. Raymond Bequest Fund Collection of The Newark Museum

Fig 12. Richard Marquis, United States, *Teapot Goblet #78*, 1989 Purchase 1990 Thomas L. Raymond Bequest Fund Collection of The Newark Museum

Fig 13. Paul Joseph Stankard, United States, *Lady Slipper Botanical*, 1984 Purchase 1984 W. Clark Symington Bequest Fund Collection of The Newark Museum

with its large abstract blue flowers against a yellow background, provides an Op-Art interpretation of the Scandinavian "graal" techniques of the 1950s. Both the Marquis and Zynsky works have technical links to the traditions of Venetian glassmaking. The piece by Zynsky, from her *Tierra del Fuego* series, demonstrates the extraordinary technical and aesthetic leap her work has made. (Fig. 11) Her use of nothing but specially made glass threads sets her apart from the 2,000-year-old tradition from which her work grows. Its roots are in the *latticino* tradition of Renaissance Murano, yet the work is wildly different from anything that preceded it. Marquis, who studied with Marvin Lipofsky, worked under a Fulbright Scholarship at two major Venetian glass factories (Salviati and Venini). In his series of teapot goblets of the late 1980s, Marquis both paid homage to and played post-modern pranks on the traditional Venetian goblet. Using the teapot as his iconic form—a form not usually associated with glass—Marquis demonstrates virtuoso skills while forcing the viewer to step back and take in his work *not* as a functional vessel, but as a sculpture *about* two vessels, each with long and complex cultural histories. (Fig. 12)

Works by New Jersey glass artists Don Gonzales, Len DiNardo, Lucartha Kohler and Paul Stankard were also added to the collection in the 1980s and 1990s, in part because of the state's centuries-old history as a glassmaking center. Of all American glass artists, Paul Stankard has most fully embraced both the limits and the artistic potential of flameworking. Trained as a scientific glassblower in New Jersey, Stankard has become one of the finest flameworkers in the world. (Fig. 13)

With the advent of the Lowenbach Collection, The Newark Museum's history of collecting modern glass is taking an historic turn, marked by their 2006 gift of *Cross Composition*, created in 1986 by Czech masters Stanislav Libensky and Jaroslava Brychtova. (Page 3) Through the ongoing generosity of these passionate collectors, Dena and Ralph Lowenbach, the Museum's collection will be able to mature and grow, even as the studio glass movement itself has done over the past thirty years.

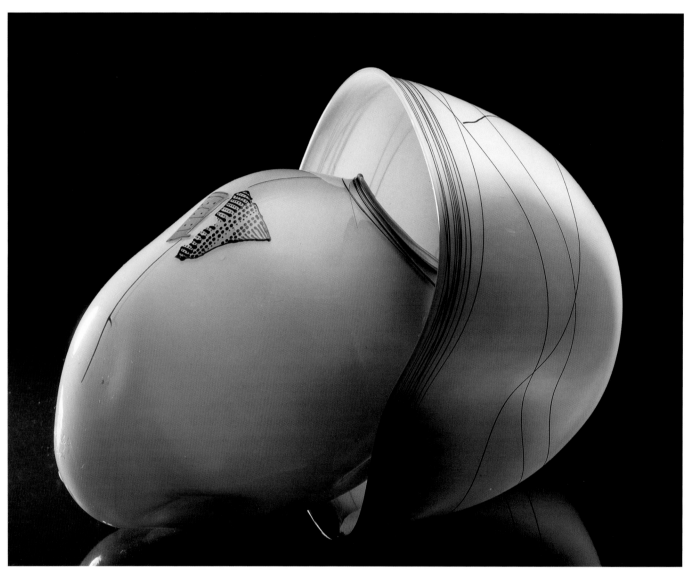

I. **DALE CHIHULY** UNITED STATES, *TWO-PART BASKET, 1979*

Highlights of the Lowenbach Collection

ULYSSES GRANT DIETZ

Formed over the past twenty years, Dena and Ralph Lowenbach's collection is as multi-faceted and layered as the studio glass movement itself. The technical, historical and aesthetic interrelationships among the diverse works in their holdings offer an edifying study of how the movement has expanded and matured since the experiments of the early 1960s. Two seminal early works distinguish the Lowenbach's collection: the *Blue Folded Form* by Harvey Littleton from 1977 (see back cover), and the *Two-Part Basket* by Dale Chihuly from 1979. These pieces sum up the aesthetic and technical ferment that was taking place in the young studio glass movement. They also underscore the ongoing tension within the studio glass world between the non-functional vessel and the purely sculptural object. Littleton was a catalyst for the development of studio glass in America. Although trained in ceramics, he led the first hot-glass workshops in Toledo in 1962, seeking a way for artists to work with molten glass by themselves in a studio, rather than in an industrial setting. Together with his collaborators and his students, he essentially created the concept of studio glass. In this piece, Littleton's love of hot glass is apparent, as is his rejection of traditional functional glass in favor of organic abstract sculpture.

Chihuly's two-part basket, relatively small in scale and subtly colored, foreshadows all of the flamboyant, multi-component works that have become his signature. (Plate 1) The first American glass artist to work in a Venetian glass factory, in the late 1960s, Chihuly was the founder of the Pilchuck glass program in Seattle in 1971. In Venice he learned the teamwork process of Muranese glassworkers, and also learned to love the lightweight, colorful glass used in Venice since the sixteenth century. Although Chihuly has remained faithful to the vessel forms natural to the process of blowing glass, this example demonstrates his early abandonment of the vessel as anything but a symbolic container and his embrace of the vessel as the source for organic sculptural forms.

The vessel is an ideal form to explore sculpturally. The fact that its historical purpose is to be a container does not diminish its potential as an artistic challenge. Whether a vessel is developed in a painterly way through surface treatment, or in a volumetric way through shaping and altering its form, it presents the artist with countless rich possibilities.

No one better demonstrates the evolution of the sculptural vessel than William Morris. A student of Dale Chihuly, Morris has pushed the technical and aesthetic boundaries of glass. His early *Stonehenge Vessel*, the first piece of studio glass acquired by the Lowenbachs, expands upon the technical developments of the Swedish glass houses of the 1950s. By adding both scale and content (iconography with personal meaning to the artist), Morris transforms a vase into a painterly sculpture. (Plate 2) In his *Petroglyph Vessel* from a few years later, the iconography has become more complex, more colorful and more personal, reflecting the artist's intense involvement with a prehistoric American wilderness. (Plate 3) As Morris's work has evolved, he has tried to turn away from the "glassiness" of his material, forcing it to better serve his artistic needs. In his *Suspended Artifact* from 1995, Morris has clearly mastered glass's unique ability to look like other materials—in this instance bone, horn, wood and metal. (Plate 4) Done, in part, to avoid the distraction of glass's seductive beauty, it also demonstrates his fascination with the ability of glass to achieve subtle effects attainable with no other medium. A more recent piece, *Medicine Jar: Crow on Corn with Grasshoppers*, created in 2005, pushes this emphasis even further. (Plate 5) Suggesting some ancient ritual vessel of the American grasslands, it is at the same time a double portrait of the two plagues of the western plains—the crow and the locust—as they attack an ear of corn, which itself symbolizes man's tenuous dominance over nature.

The vessel as sculpture need not move as far from its decorative arts roots as Morris takes it. Dan Dailey, who founded the glass department at the Massachusetts College of Art in 1973, has over the past thirty years transformed the vessel into a vehicle for his fantastical cartoon-like "busts," exemplified by his *Poem Man* of 1992. (Plate 6) Trained as a potter and as a cartoonist, Dailey uses glass in ways that are both sculptural and painterly. Having worked with glass in industrial settings in France and in Italy, he has incorporated nearly every technique—casing, carving and enameling—into his personal vision. Duncan McClellan and Lisabeth Sterling take on the Bohemian tradition of pictorial engraving on cased glass and imbue it with a modern graphic style as well as a complex iconographic content. McClellan

achieves a three-dimensional translucency that draws the viewer into his *Cold Winter Night* of 1998. (Plate 7) His vessel forms tend to be simple and large scale, to provide the broad canvas on which he "paints" his images. Sterling has replaced the technically advanced but purely decorative engravings of Bohemian glass with powerful expressionist images inspired by German printmaking of the early twentieth century. Although the meaning of the images in her 2001 work *Yes or No* is intentionally vague, their emotional impact is clear. (Plate 8) Sterling achieves subtle gradations in tone through careful exploitation of her skill as a glass engraver. Japanese artist Kazumi Ikemoto expands on Maurice Heaton's enameling of the 1940s, using a mouth-airbrush to place softly translucent surfaces onto a blown and sandblasted vessel. Although enameling on glass in the West dates back to antiquity, it is a relatively new technique in Japan. Like Sterling and McClellan, Ikemoto sees his vessels as canvases. His enameled scenes evoke lyrical, fantastic landscapes with a dreamlike quality. (Plate 9)

The optical clarity of glass contrasted with the opacity of metal is at the root of two vessel-based sculptural glass artists, Michael Glancy and Jose Chardiet. Inspired by the microscopic study of the nature of living things, Michael Glancy produces his opulently textured works by electroforming copper and other metals onto sandblasted blanks. He starts with classic vessel forms, produced in conjunction with a master glassblower in Sweden, and then transforms them into seething organic compositions. The contrast in material textures, as well as the physical detachment provided by the geometric stacked base, removes Glancy's work from the realm of the functional object. (Plate 10) The Cuban-born Chardiet plays with the concept of the vessel and the still-life, elevating mundane objects to the status of mysterious totems. This teapot, one of a series that evokes both domestic ritual and the streetscapes of the artist's own Providence, Rhode Island, manages to be both cozy and cold. (Plate 11) The contrast of the opaque metal cladding and the pellucid glass lures the viewer closer in the attempt to see what lies inside, even as the alien, prickly handle rejects any attempt to handle it as one would an ordinary teapot.

The nature of Venetian glass was a revelation to Dale Chihuly when he worked at the Venini factory in Murano in 1968. His colorful forms evoke the modernist glass that characterized Venetian work in the 1950s, while at the same time displaying a distinctive theatricality that has grown out of his personal sense of color and his understanding of the controlled spontaneity of the collaborative glass-making process. *Blue Venetian* from 1988 exemplifies Chihuly's mastery of the Venetian idiom, even as his manipulation of scale and the practice of naming his works in series separates them from the realm of decorative arts. (Page 2) As a counterpoint to Chihuly's "enamored outsider" approach to Venetian glass, his peer and sometime collaborator, Lino Tagliapietra, is a native Venetian and was a master glassmaker in Murano by 1955. Tagliapietra is celebrated worldwide for sharing his incomparable technical skills

with young glassmakers. In this work, from his Bilbao series (see front cover), he uses all of the classic Muranese techniques, but in a strikingly original way. The viewer can see the influence of sculptor Henry Moore in the way the piece changes with the viewer's perspective, a shifting vision of exterior form and internal space. Part of a series that was inspired by the multiple volumes of architect Frank Gehry's Guggenheim Museum in Bilbao, Spain, this vessel capitalizes on the color and transparency of glass to draw the eye in and through its form.

Although still a toddler when Tagliapietra became a master, Davide Salvadore was also born into the Muranese glassmaking tradition. Like Tagliapietra, his use of colored glass canes and his subtly carved surfaces grow directly out of his Venetian roots. His forms and colors, however, are inspired by African objects and textiles. (Plate 12) Salvadore carves his surfaces so as to make his work tactile, echoing the tooling on Venini's *Notte* vase from the 1950s. (Fig. 6) Both Richard Marquis's 1989 *Teapot Goblet #78* and Charles Savoie's 2003 *Serafina Goblet* demonstrate the groundswell of interest in this once-functional Venetian form. (Fig. 12 and Plate 13) Savoie's sculptural goblets are post-modern evocations of the virtuoso works of nineteenth-century Murano. Having studied sculpture, Savoie was drawn into glassmaking by the idea of solitary hot glass work. He focuses on the goblet as an abstract form, working with his extensive knowledge of glass chemistry to produce a brilliant color palette.

Stephen Rolfe Powell approaches another traditional Venetian form, the bottle, as an opportunity for an exploration of scale and color. Trained as a potter, Powell was introduced to Venetian glassmaking techniques using colored glass beads or disks, called *murrine*, by Richard Marquis. Powell has made the technique his own with his virtuoso explosions of color and pattern. (Plate 14) The *murrine* are produced in Powell's studio, arranged on a metal plate or marver, and then picked up with a gather of hot glass to be blown and formed. The large fig-shaped lobed bottle is one of his iconic forms. In all of Powell's vessels, one is aware of the maker's breath, stretching the thin membrane of hot glass and giving life to the vivid colors trapped in the murrine. Ultimately, Powell's work is a celebration of the unique properties of glass, its transparency, plasticity and color. His more recent works have moved further from the more literal bottle forms, taking on a formal abstraction that reflects the same sort of process in Chihuly's *Persian* series. (Plate 16) One of the great appeals of Chihuly's work is that it can be viewed in multiple ways. His *Persian* series consists essentially of abstract still-lifes of non-functional vessels, evoking the exotic other, much the way that the glass of Louis Comfort Tiffany did a century earlier. Mixed into the echoes of ancient Islamic and art nouveau glass is a strong sense of life, that somehow these assembled pieces are organisms, fleeting and fragile. As with every Chihuly piece, this is a paean to the qualities of color and light unique to glass.

Ironically, Laura de Santillana's work looks far more removed from her Venetian roots than it really is. (Plate 17) A granddaughter of Paolo Venini, Santillana studied graphic art in the United States before returning to her native Venice to work with glass. Her vessels become non-functional in the collapsing of the large blown form. The hollow tablets thus created (which the artist refers to as "bricks"), rely for their power on subtle effects of muted luminous color. It is interesting to compare her work with the *Notte* vase produced at her grandfather's factory in 1958. (Fig. 6)

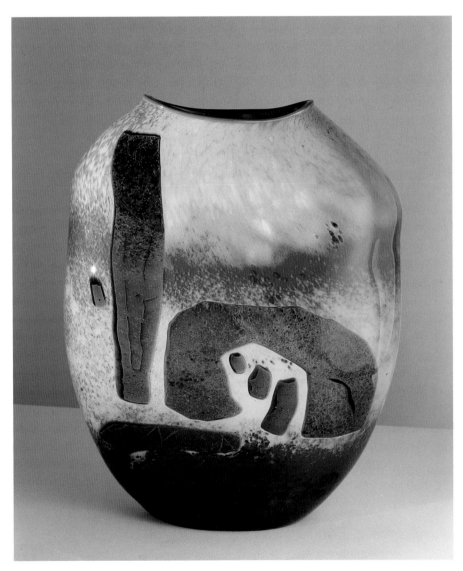

2. **WILLIAM MORRIS** UNITED STATES, *STONEHENGE VESSEL*, 1985

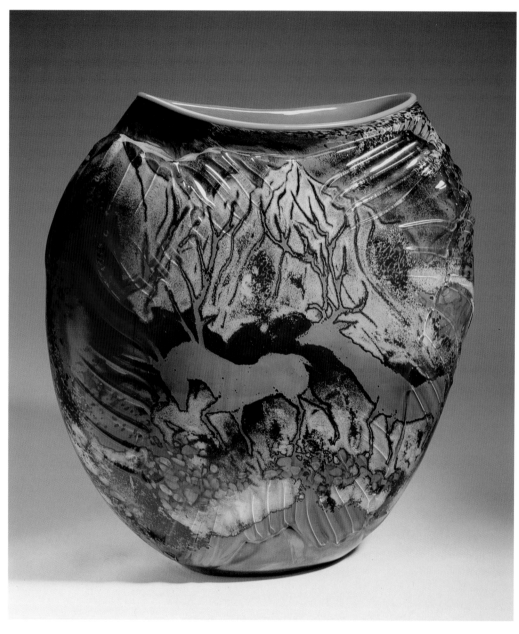

3. **WILLIAM MORRIS** UNITED STATES, *PETROGLYPH VESSEL*, 1989

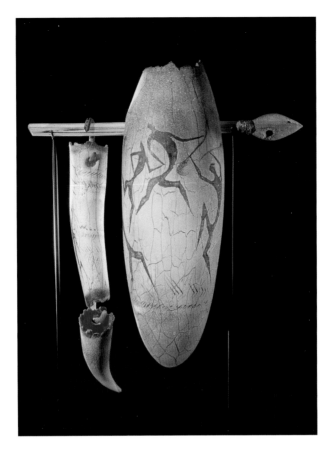

4. **WILLIAM MORRIS** UNITED STATES, *SUSPENDED ARTIFACT*, 1995

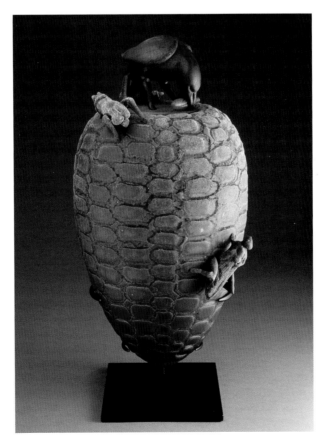

5. **WILLIAM MORRIS** UNITED STATES, *MEDICINE JAR: CROW ON CORN WITH GRASSHOPPERS*, 2005

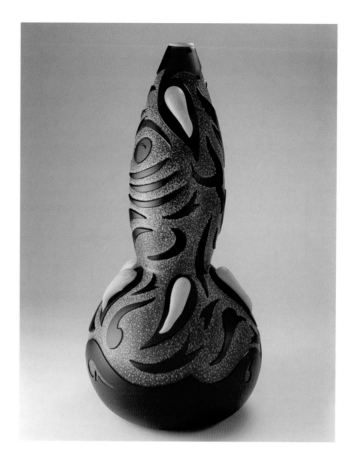

6. **DAN DAILEY** UNITED STATES, *POEM MAN*, 1992

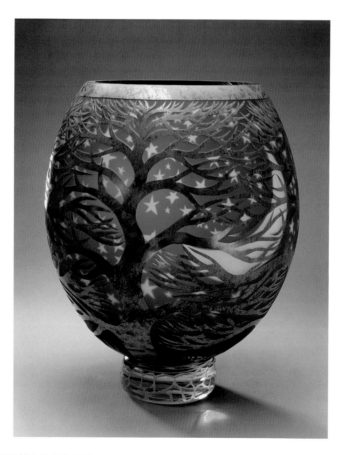

7. **DUNCAN MCCLELLAN** UNITED STATES, *COLD WINTER NIGHT*, 1998

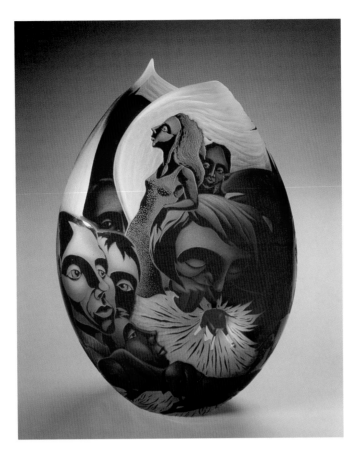

8. **LISABETH STERLING** UNITED STATES, *YES OR NO*, 2001

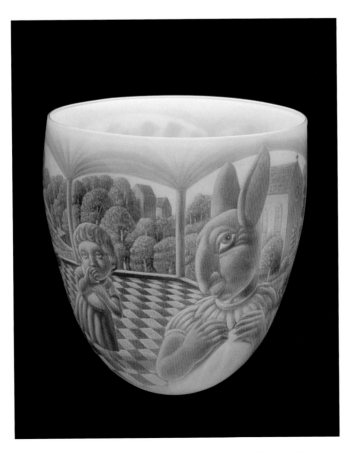

9. **KAZUMI IKEMOTO** JAPAN, *SCENE 0203*, 2005

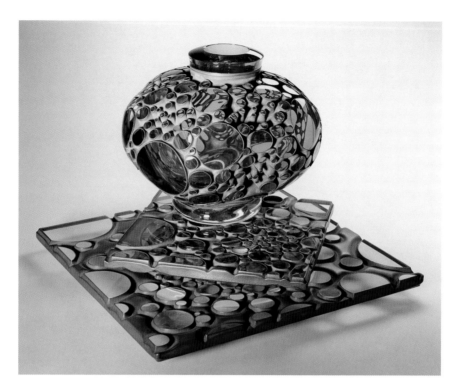

10. **MICHAEL GLANCY** UNITED STATES, *COMPLEX CONVOLUTION*, 1997

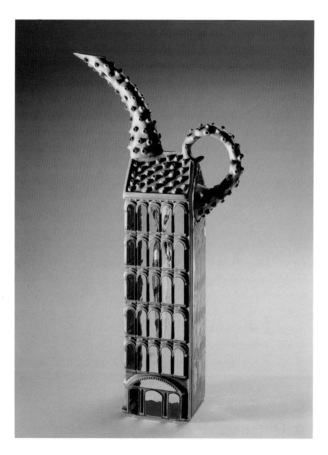

11. **JOSE CHARDIET** UNITED STATES, *WICKENDON TEAPOT*, 2003

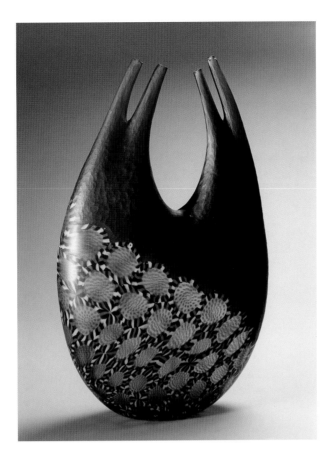

12. **DAVIDE SALVADORE** ITALY, *UNTITLED*, 1995

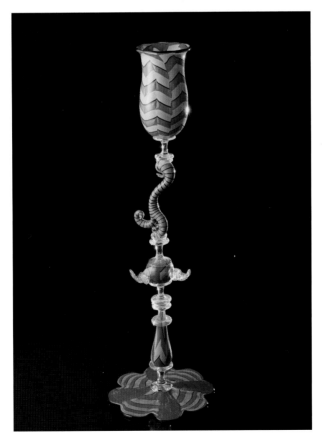

13. **CHARLES PAUL SAVOIE** UNITED STATES, *SERAFINA GOBLET*, 2003

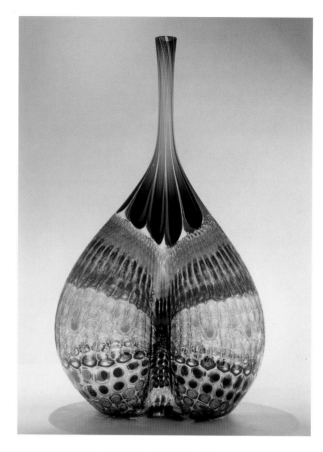

14. **STEPHEN ROLFE POWELL** UNITED STATES, *ORDERED CHAOTIC CLEAVAGE*, 2002

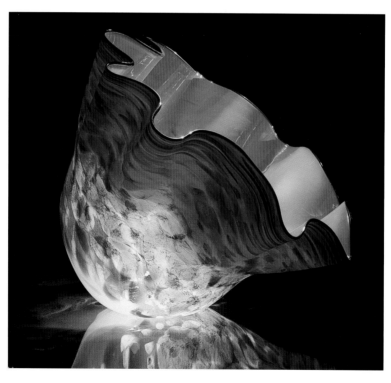

15. **DALE CHIHULY** UNITED STATES, *BURNING RED MACCHIA WITH ASH LIP WRAP*, 2002

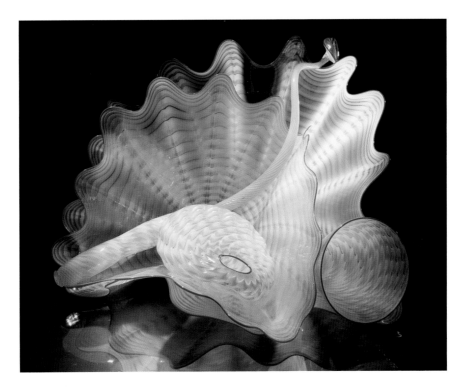

16. **DALE CHIHULY** UNITED STATES, *GOLDEN SULFUR PERSIAN SET*, 2004

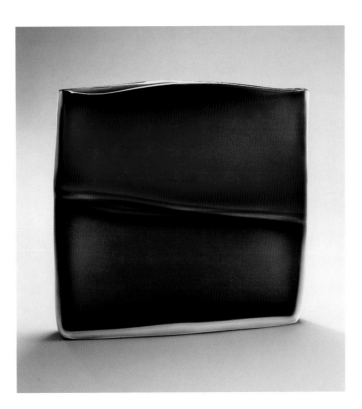

17. **LAURA DE SANTILLANA** ITALY, *UNTITLED*, 2003

Glass artists approach the figure in an astonishing variety of ways, because of the rich narrative potential of representational art. Furthermore, artists can exploit the qualities of the medium to achieve a wider range of psychological and emotional expression than is possible in other materials such as stone, metal and wood. Only clay approaches the flexibility of glass, but glass also possesses the unique ability to transmit and diffuse light, something the figural works in this section use to great advantage.

Trained as a painter at the Rhode Island School of Design, Judith Schaechter has embraced and mastered the complex technical aspects of stained glass production, without letting the allure of the material's beauty derail her intense and rather dark personal vision. Included in the 2002 Whitney Museum Biennial, her 2000 work *Rejects* incorporates pieces that were rejected from earlier works. The jostling crowd of disembodied heads (and one headless body) is a microcosmic sampling of the many strange, whimsical and brooding characters that populate her distinctive vision. (Plate 18)

Miriam Di Fiore, trained as a potter in Argentina, starts with her own photographs of landscapes, each with deep personal associations. Using a technique she refers to as "light painting," Di Fiore builds up layers of ground glass on a sheet of American plate glass, repeatedly firing the piece to build depth and color. Her fused glass paintings are nearly always framed in other materials, to create a physical context that amplifies the emotional resonance of the image. In this work, a winter pond seems to wait, cold and still, suspended between life and death, the lone snail shell a harbinger of the coming resurrection of spring. (Plate 19)

Growing out of the artistic success of the *pâte de verre* technique developed in French art glass early in the twentieth century, the use of cast glass has become an important way for studio artists to exploit the psychological potential of their medium. Russian-born Asya Reznikov has created an emotionally charged sculpture that uses the quality of the material to underscore its message. The translucent deep red of the glass itself suggests blood, filling the figure but contained beneath the surface, while the pose and the cord binding the figure's legs suggest both captivity and resignation. The mysterious little chamber in the figure's chest seems to be the source of all this, but the viewer can only guess at what it symbolizes. (Plate 20) Rick Beck, by contrast, is a master at enlarging mundane domestic artifacts to heroic scale, forcing the viewer to reevaluate the potential grace of the everyday object. What might at first

glance appear to be an abstracted reclining nude figure is in fact a pair of scissors "posing." (Plate 21) By recreating metal objects in fragile, light-diffusing glass, he forces the viewer to approach them with a kind of diffidence—even reverence—usually reserved for the human figure.

Christina Bothwell presents us with mysterious figures that walk a fine line between the whimsical and the sinister. *Little Friends* most obviously refers to the myth of Romulus and Remus, the abandoned twin sons of Mars who were raised by a she-wolf and were the founders of Rome. (Plate 22) The work also seems to suggest a contrast between innocence and savagery. However, the benign look of the she-wolf in contrast with the rather scary children might alternatively suggest modern-day toddlers, catered to in every way by guilty parents, riding roughshod over their caretakers in their demand for attention. Hank Murta Adams presents a similar conundrum with his cast heads, often bristling with metal and, in this case, a water meter. (Plate 23) Adams embraces the translucence of his material for its ability to give his work an inner spirit, but it is not clear whether we are to see this head as a comical, cartoon-like image or as a darker, Frankenstein-like creation. Bertil Vallien, coming from the industrial tradition in Sweden, is one of the major figures of international studio glass today, dividing his time as a designer for Kosta-Boda and as a studio artist. He is best known for his sand-cast sculptures, which both capitalize on glass's transparency through inclusions of small symbolic objects, and simultaneously deny that transparency with opaque exteriors dusted with powdered glass. *The Artist*, from 1990, exemplifies the layered richness of Vallien's iconography, combining the image of a house-like structure with a mysterious shadow-like portrait. (Plate 24)

Oben Abright gets to the translucence of glass by mold-blowing his figures and then painting them. (Plate 25) His passion for drawing and for comic books infuses the vivid representational style of his figural work. His surface treatment with oil paint softens the jewel-like quality of the glass, insuring that the material does not overwhelm the subtlety of the modeling. Robert Palusky, a longtime teacher of ceramics as well as glass, creates figural narrative works that include paint sandwiched between layers of glass. In *Family Values—Staying Afloat* the flattened painterly aspect of his work competes with the sculptural aspect, increasing the precarious sense of balance. The position of the nesting bird on the cat's back and the awkward pose of the female figure suggest some sort of desperate cooperative effort. (Plate 26) Richard Jolley is faithful to the hot-working techniques embraced at the Toledo workshops of the early 1960s. In this work from his totem series of the 1990s, using a blowtorch to shape the various subordinate elements, Jolley pushes the scale limitations of hot-glass work by assembling four smaller figures into a monumental whole. (Plate 27) In *Endurance of Beauty*, the lower figures struggle heroically, like Prometheus or Atlas, while the triumphant, but headless, body at the top calls to mind the incomplete-yet-beautiful

statues of antiquity. The brilliant blue head that supports the top figure evokes one of those disembodied Roman heads one sees in museums. Its slightly surprised expression seems to be the result of its position below the rest of the body.

Karen LaMonte produced her mixed-media *Gluttony* in 1996, when she worked at Urban Glass in Brooklyn. The puppet-like figure, captured under a hand-blown bell jar like some grotesque specimen in an arcane museum, is one of the "Seven Deadly Sins" that LaMonte produced as a series. (Plate 28) The series grew out of her study of children's toys and the way they bridged imagination and reality. Most important to LaMonte, who has since moved to the Czech Republic and become known for large-scale cast glass sculptures, is the subjugation of technique to content. She is a master glassmaker, but one who does not allow her skills to overshadow the psychological impact of her sculptures.

The lampworking, or flameworking, that LaMonte used in her early pieces limits the scale available to a glass artist. Manipulating glass over an intense open flame is a technique with roots in antiquity that is central in the traditional products of Murano glassmakers. Shane Fero's contemporary take on the Venetian glass figures of the 1930s and 1940s focuses on an anthropomorphic water bird holding its fledgling aloft, seemingly frozen mid-step in some celebratory dance. (Plate 29) It calls to mind the *Bacchante and Infant Faun* of American sculptor Frederick MacMonnies, transmitted through a surrealist lens and capitalizing on the unique possibilities of color and spontaneity that only glass affords. Jeff Spencer developed his skills under master flame-worker John Burton in the early 1970s at Pepperdine University in Los Angeles. An Olympic cyclist as well as a sports chiropractor, Spencer is sensitive to the form and workings of the human body, an influence evident in the suggestive narrative in *Helping* from 1997. (Plate 30)

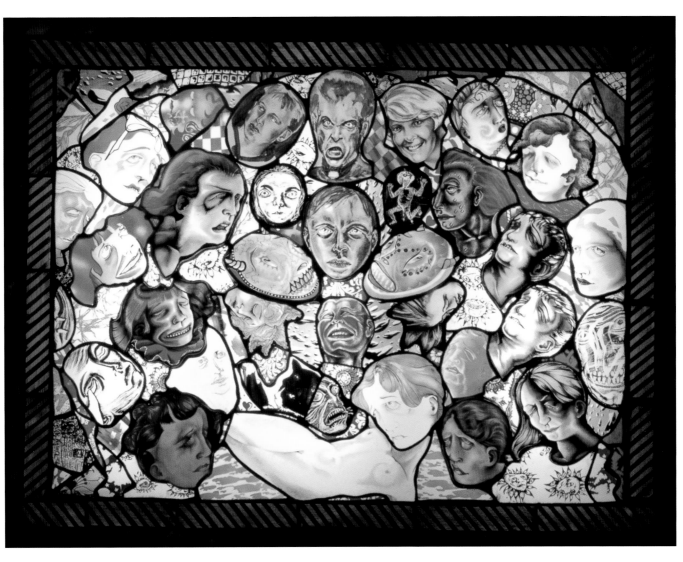

18. **JUDITH SCHAECHTER** UNITED STATES, *REJECTS*, 2000

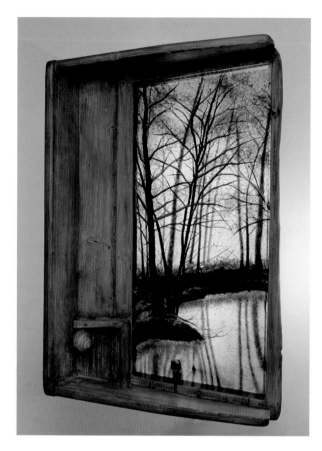

19. **MIRIAM DIFIORE** ITALY, *SNAIL'S DREAM*, 2003

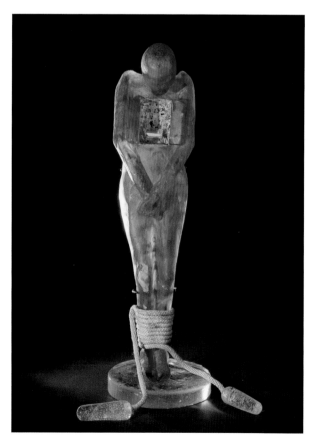

20. **ASYA REZNIKOV** UNITED STATES / RUSSIA, *BOUND*, 2002

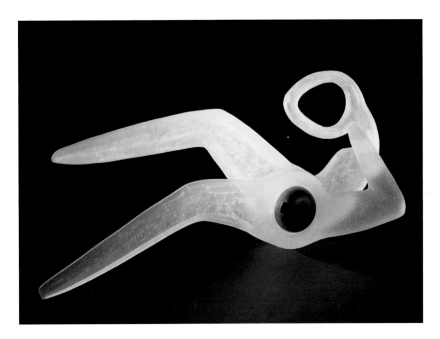

21. **RICK BECK** UNITED STATES, *CLEAR RECLINING SCISSORS*, 2005

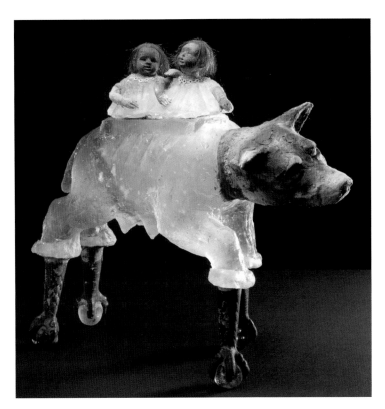

22. **CHRISTINA BOTHWELL** UNITED STATES, *LITTLE FRIENDS*, 2003

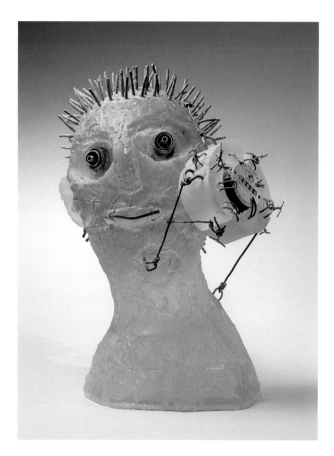

23. **HANK MURTA ADAMS** UNITED STATES, *HEAD WITH MONITOR*, 2003

24. **BERTIL VALLIEN** SWEDEN, *THE ARTIST*, 1990

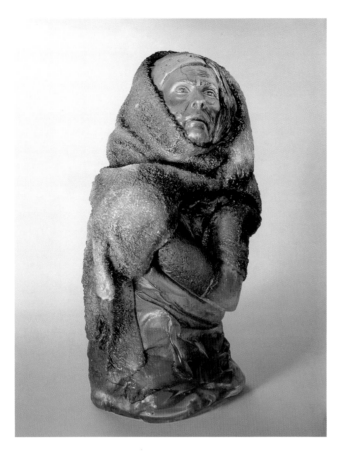

25. **OBEN ABRIGHT** UNITED STATES, *LOSS SERIES NO. 7*, 2005

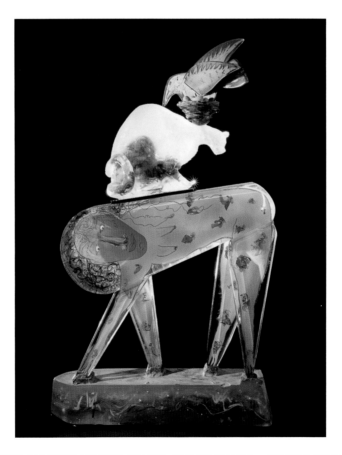

26. **ROBERT PALUSKY** UNITED STATES, *FAMILY VALUES — STAYING AFLOAT*, 1996

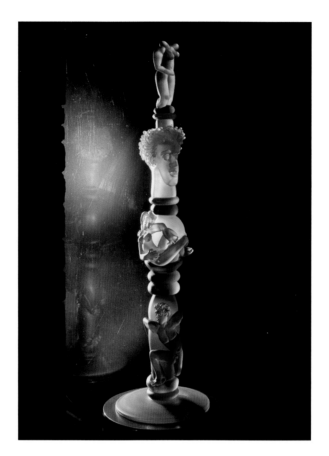

27. **RICHARD JOLLEY** UNITED STATES, *ENDURANCE OF BEAUTY*, 1999

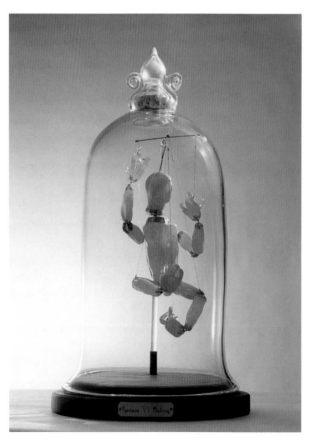

28. **KAREN LAMONTE** CZECH REPUBLIC / UNITED STATES, *GLUTTONY*, 1996

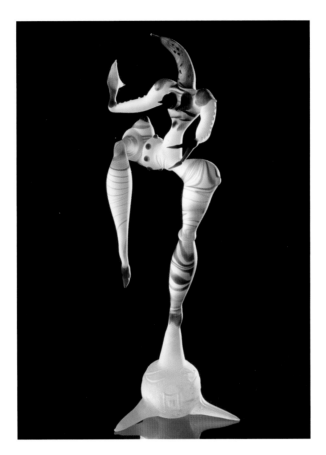

29. **SHANE FERO** UNITED STATES, *ANHINGA AND BABE*, 1998

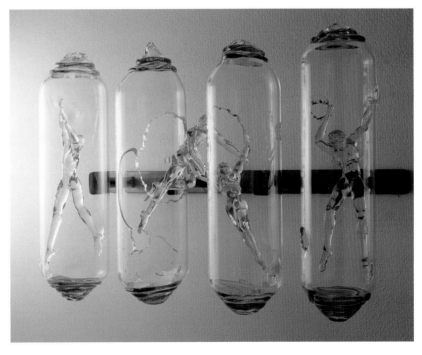

30. **JEFF SPENCER** UNITED STATES, *HELPING*, 1997

Abstraction in glass sculpture is as much about the denial of the functional form as it is about belonging to a larger body of abstract art. The artists in this final section have all sought to use glass to create works of complex color, form and texture. Some have tried to deny the "glassiness" of glass to avoid the lure of the merely pretty; others have embraced the medium's unique optical or coloristic qualities in order to achieve results obtainable in no other material. In every case the intention of the artist is to provoke emotional and intellectual responses in the viewer by expressing his or her own unique vision. When confronted with abstract art, we can never be quite sure of the artist's intention; we can only be sure of our own reaction to it.

As the single most important catalyst for the glass-as-art movement in the 1960s, Littleton's work has defined both the rejection of glass's decorative arts legacy and the embrace of its most alluring qualities—color, transparency and molten fluidity. *Ruby and Blue Linked Form*—one of his archetypal color compositions of the late 1980s embodies Littleton's duality as an artist, his passion for hot glass and his determination not to let that passion override his artistic vision. (Plate 31) His sculptures are rooted in the abstract tradition among painters of his generation such as Morris Louis and Helen Frankenthaler. Thomas McGlauchlin, on the other hand, was still producing technically brilliant vases in the Swedish tradition in the early 1980s, a fine example of which is in the Museum's collection. However, by 1985 he had made a determined shift away from the decorative arts to abstract sculpture. McGlauchlin produced a series of sculptural assemblages made of blown elements, which were sand-blasted and dusted with enamels, creating a softly abrasive surface that only reveals itself as glass after careful inspection. (Plate 32) Having been raised in the blown hot-glass tradition, McGlauchlin sought in these works to deny what was perceived as the shallow prettiness of blown glass, and to explore the purely sculptural possibilities of the medium. In spite of the wish to deny the "glassiness" of the material, these lyrical sculptures could have been achieved in no other medium.

In spite of their visual weight, they betray a lightness that belies their apparent solidity. It is interesting to compare McGlauchlin's spheres with the work of Japanese artist Toshio Iezumi, who exploits the sculptural potential of glass in a startlingly counterintuitive way. He uses industrial plate glass—with its characteristic green tint—laminating it and then grinding it away to produce his biomorphic, jewel-like sculptures. (Plate 33) He embraces the inherent nature of the material—its transparency and

34

reflectivity—to produce objects of quiet beauty. The surprise here is that he achieves this result by a mechanical, reductive process, producing something that looks as if it had been formed with molten glass.

The use of sheet glass, cold-worked to achieve calculated optical effects, is usually less deceptive than it is in Iezumi's work. Vladimir Kopecky, who now heads the glass department at the Academy of Fine Arts in Prague, has long used sheet glass, stacked, painted, sandblasted and framed, to make minimalist three-dimensional works that are simultaneously sculpture and painting. (Plate 34) The transparency of glass is used to create a striking sense of depth, but the artist works with glass as a collagist works with layers of paper. Tom Patti is the American master of this minimalist approach, yet maintains both visual and technical links to the hot-glass tradition. Having been called "monumental sculpture on an intimate scale," Patti's work combines mastery of a complex technical process with an intellectual rigor that has given him a unique position among American glass artists. Working slowly, with scientific precision, Patti laminates multiple layers of glass, then heats the result and releases a bubble of air inside the layers. (Plate 35) Having originally been open at the top, and therefore technically vessels, his works have evolved into fully enclosed minimalist sculptures, each one having a serene beauty that belies the intense focus that attends their creation.

Sydney Hutter was also trained in the traditions of hot glass, but he has become known for creating vessel forms out of assembled and laminated sheets of polished plate glass. In this example, the DNA-like spiral that sometimes appears within his layered vessels has become the main focus. (Plate 36) The artist revels in using a functional, industrial material in a way that denies the material's utilitarian purpose, thus offering the viewer a chance to explore concepts of volume, form, light and color in a way that is purely aesthetic and emotional. Jon Kuhn, trained in ceramics and woodworking, is yet another artist who took to cold-worked glass after starting out with hot glass. Like Tom Patti and Toshio Iezumi, Kuhn laminates industrial sheet glass with epoxy, then polishes and grinds his assemblages into their final form. However, Kuhn is more focused on the potential optical effects of the different kinds of colorless and colored glass he employs. He is particularly interested in how the viewer experiences light as it passes through the solid outer layers and is shot back from the scintillating core of his sculptures. (Plate 37) His designs are based on a mathematical precision that has its roots in his study of Eastern philosophy.

William Carlson's work of the 1980s embodies an iconic post-modern aesthetic that expresses his fascination with contrasts in texture, color, transparency and geometric form. Like many of his peers, he was trained as a potter and moved to hot-glass working. Having started out exploring the effects of cutting through blown forms to expose their interiors, he moved to complex assemblages of laminated mixed media, which he cuts and polishes. (Plate 38)

Hot-worked glass naturally lends itself to the creation of biomorphic abstract forms. Janet Kelman takes biomorphism literally, evoking seafan corals in her large-scale sculptural pieces. Kelman was drawn into glass as a scientist, through the lampworking skills needed to make scientific instruments. Her technical interests shifted to kiln-slumped glass and sandblasting, which formed the basis of a business in architectural glass. It was scuba diving that opened her eyes to the artistic possibilities of slumped and sandblasted glass, inspiring her with the exotic shapes and colors of underwater life. (Plate 39) Using large crowns (blown roundels) of colored glass made to her specifications, she carves the surfaces and edges with a sandblasting needle, then heats them repeatedly to achieve the final complex three-dimensional shapes. The biomorphic shapes that form the foundation of Dale Chihuly's *Persian* series, begun in 1986, evolved from the *Seaforms* that he produced in the early 1980s. Less literal than Kelman's seafans, the organic asymmetry of underwater life—striated surfaces, undulating outlines, shifting colors—are all evident in the *Persian* series, as they are in the *Macchia* series begun at the same time. (Plates 15, 40 and Page 2) Here Chihuly's intent has expanded to evoke ancient Near-Eastern glass as well as the art nouveau glass of the early twentieth century.

Marvin Lipofsky is known best for his organic abstractions. Trained as a sculptor, he was among Harvey Littleton's original students who turned to hot glass as an artistic medium. Although his work has come a long way from the early experiments of the 1960s (such as the one shown in Fig. 10), his central interest in abstracted organic forms, in interior volumes and in the physical possibilities of the glass itself are all still primary. Working with a team, Lipofsky approaches glass the way abstract painters approach paint. Like many of his peers, he has worked with other glass artists around the globe, sharing his knowledge and learning from them. (Plate 41) German artist Jörg Zimmerman focuses on the essential structure of blown glass—the bubble—as the creative premise of his mysterious biomorphic abstractions. He blows his glass through or around special wire meshes that have a high melting point, achieving the cell-like structures he then amplifies through cold-working techniques of polishing and grinding. Although they refer to vessels, his works are meant to be seen simply as sculptures, evoking something vaguely alien and organic. (Plate 42)

Eric Hilton was trained in traditional glass-cutting in his native Scotland and has worked for many years as a designer for Steuben Glass. He uses Steuben lead-glass blanks as the base material for his complex abstract visions. Here, in a metal mount that calls to mind a laboratory slide of protozoan life, the contrasting transparent and matte surfaces play with whatever light and color surround the piece to provide a distinctly different experience in every setting. (Plate 43) Although essentially abstract, even the title of Hilton's work *Time's Source* seems to suggest some vaguely futuristic piece of equipment.

John Lewis came to glass through Marvin Lipofsky, but shifted from blowing to casting with industrial technology. Ten years after opening his studio in 1969, he focused on cast sculptural/functional pieces and architectural work, relying on the structural strength of cast glass. While this table, one of a series he produced in the late 1990s, is clearly designed as a functional object, its strongly abstracted geometry and massive cast elements give it a strong sculptural presence. (Plate 44)

Mary Shaffer is also interested in the structural strength of glass, but not in a functional sense. She studied at the Rhode Island School of Design, where she trained as a painter. Through Fritz Dreisbach, who was substituting for Dale Chihuly in RISD's glass program, she learned the sculptural possibilities of working with slumped glass. *Center Cube* from 1992 is an iconic example of her work with slumped plate glass—in which the heated glass is allowed to fall without intervention, and then to cool, thus capturing that moment when it changes from solid to liquid. (Plate 45) The glass has been cast in bronze for the companion piece, which creates a striking contrast between the dark solidity of the metal and the transparent lightness of the glass.

Stanislava Grebenickova represents a whole generation of mid-career Czech artists who studied with glass master Stanislav Libensky in Prague. Like many glass artists of the last two decades, she is global in her experience, having studied and taught in the United States, the Netherlands and Spain, while showing her work in Japan and England as well. Her work combines the geometric minimalism emblematic of Czech sculptural glass with a distinctive use of texture and color. In this work, *Night Sky*, the polished oval and triangular planes contrast with the rough surfaces that speak of the casting process. (Plate 46) The evocative title is not meant to suggest any literal image, but to offer possibilities to the viewer. One can almost imagine this sculpture to be a mysterious portal through which one can study the vastness of space.

Of the same generation as Harvey Littleton, the celebrated duo of Stanislav Libensky and Jaroslava Brychtova shaped an entire generation of glass artists in Europe, and has had global influence in the use of glass as an artistic medium. The couple embraced the limitations of the Communist-run glass factory system to attain their artistic vision, exploiting the technical possibilities of large annealing furnaces and quantities of colored glass, for which the Czech glass industry has long been famous. Libensky/Brychtova are celebrated for their large-scale minimalist sculptures, in which monochromatic cast glass capitalizes on the translucence of the material to produce serene works that change in mood as the light around them shifts. (Plate 47 and Page 3) The dark red-brown *Cross Composition* of 1986 and the grey-blue *Spaces VI* of 1994-95 epitomize Libensky/Brychtova's work in their spare but complex geometry, in their jewel-like colors, and in their ability to use light as an active part of their visual impact—through

both reflection and transmission of light. The couple's mastery of difficult glass technology is subsumed by the elegant austerity of the work itself. Coming from the sort of decorative arts tradition in which François Décorchemont made his experiments with casting glass back in the 1910s and 1920s, these two have transcended that tradition without denying the essential qualities of their medium.

The pieces included in this exhibition and accompanying catalogue, as diverse as they are in style and technique, represent less than half of the Lowenbachs' collection of contemporary studio glass. The range of works lent to this exhibition demonstrates their fine eye as collectors and their enduring passion for the art of glass. Seen alongside The Newark Museum's ninty-four-year history of collecting modern glass, these pieces offer each of us a unique insight into the history of glass as art across the twentieth century.

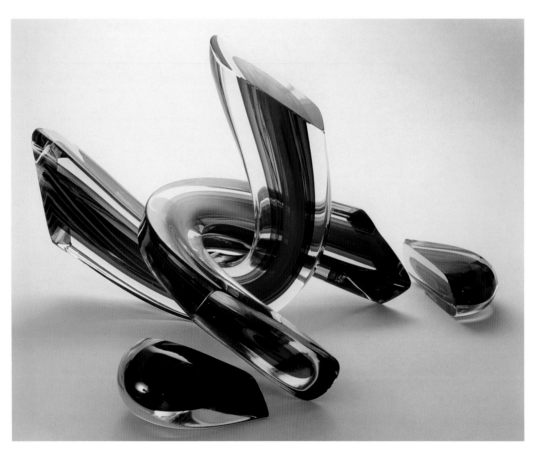

31. **HARVEY LITTLETON** UNITED STATES, *RUBY AND BLUE LINKED FORM*, 1988

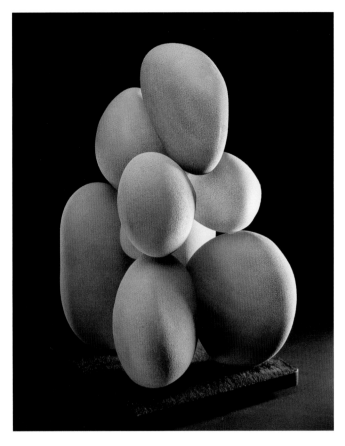

32. **THOMAS MCGLAUGHLIN** UNITED STATES, *IRREGULAR SPHERES*, 1985

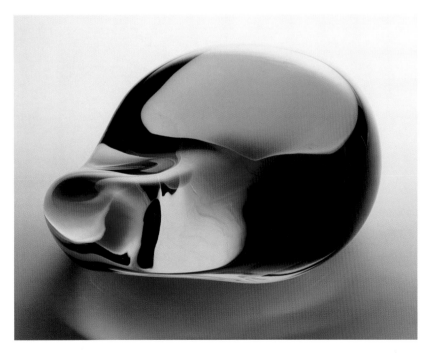

33. **TOSHIO IEZUMI** JAPAN, *F.021203*, 2003

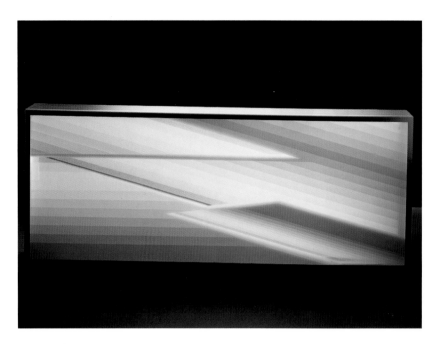

34. **VLADIMIR KOPECKY** CZECH REPUBIC, *UNTITLED*, 1980

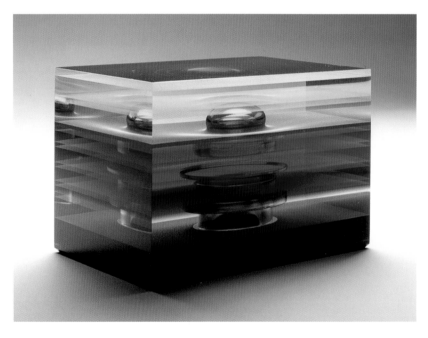

35. **THOMAS PATTI** UNITED STATES, *ASAHI LUMINA WITH CLEAR*, 1991

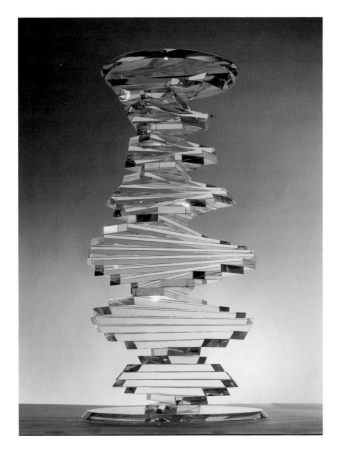

36. **SYDNEY HUTTER** UNITED STATES, *TWISTED ABSTRACT STRIP VASE*, 1991

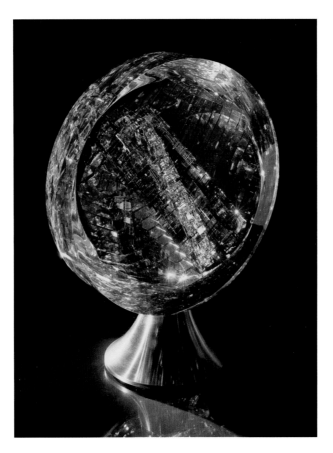

37. **JON KUHN** UNITED STATES, *PURE REASON*, 2003

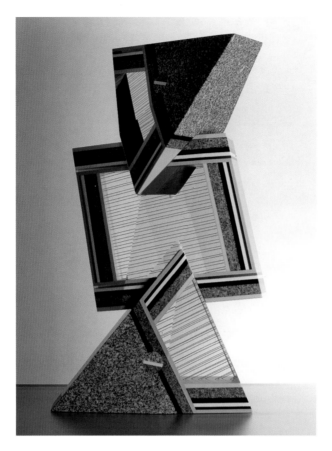

38. **WILLIAM CARLSON** UNITED STATES, *PRÄGNANZ, 1989*

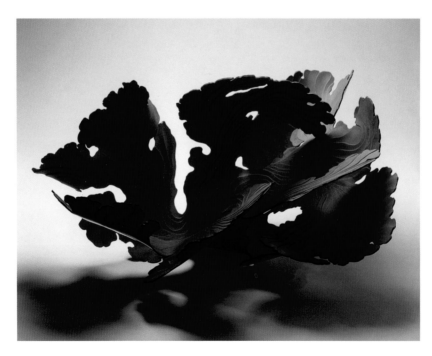

39. **JANET KELMAN** UNITED STATES, *COBALT SEAFAN, 2002*

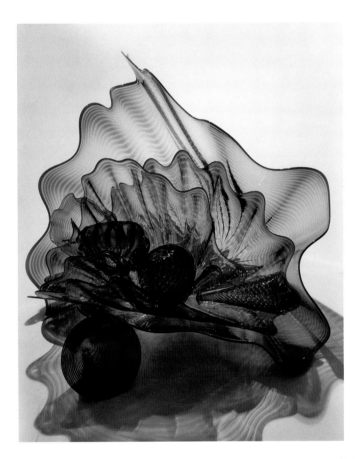

40. **DALE CHIHULY** UNITED STATES, *COBALT VIOLET DEEP PERSIAN SET*, 1993

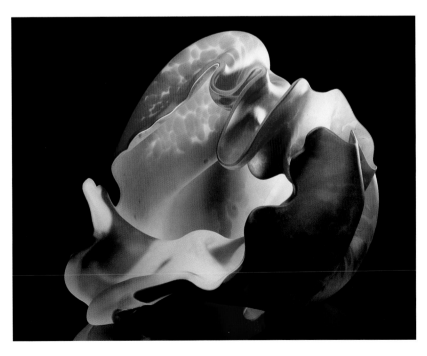

41. **MARVIN LIPOFSKY** UNITED STATES, *?IGS VI 1997-98 #4*, 1997

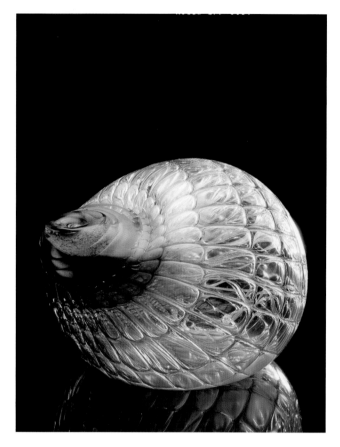

42. **JÖRG ZIMMERMAN** GERMANY, *YELLOW JR. II*, 2001

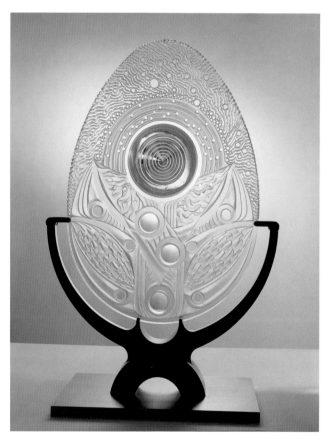

43. **ERIC HILTON** UNITED STATES, *TIME'S SOURCE*, 1996

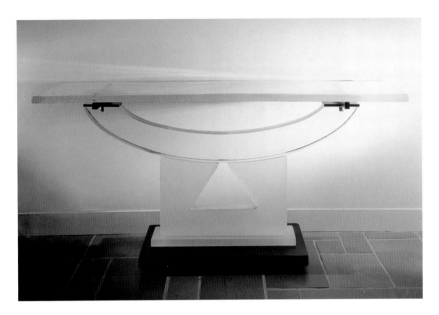

44. **JOHN LEWIS** UNITED STATES, *GOLD TRIANGLE*, 1996

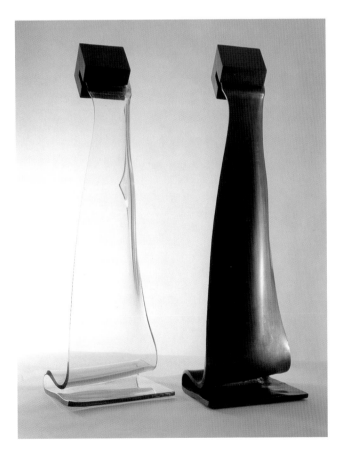

45. **MARY SHAFFER** UNITED STATES, *CENTER CUBE*, 1992

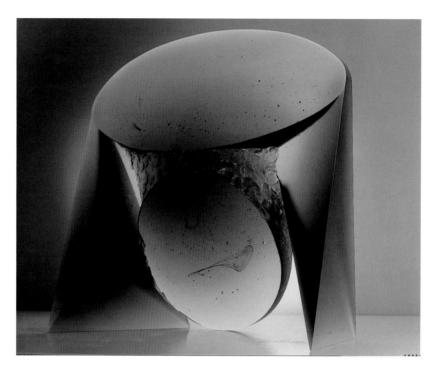

46. **STANISLAVA GREBENICKOVA** CZECH REPUBLIC, *NIGHT SKY, 1999*

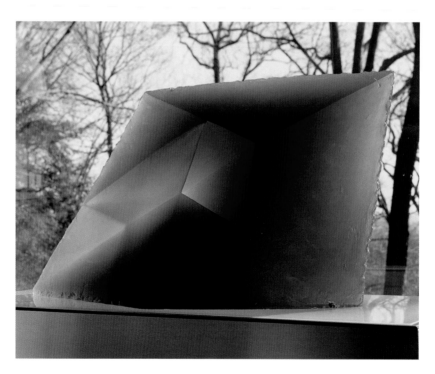

47. **STANISLAV LIBENSKY AND JAROSLAVA BRYCHTOVA** CZECH REPUBLIC, *SPACES VI, 1994-95*

All dimensions are in inches. Height precedes width precedes depth.

COLLECTION OF THE NEWARK MUSEUM
(in order of acquisition)

1. **Emile Gallé**, France
Vase with design of chrysanthemums, ca. 1900
14 × 4 ⅝
Purchase 1921 *21.285*

2. **Johann Oertel and Company**, Bohemia (Czech Republic)
Vase, 1922
5 ¾ × 5 ¾
Purchase 1923, Gift of Otto Kahn
23.229

3. **Catherine Lamb Tait for J. and R. Lamb Studios**, United States
Art Education Window (the Hugo Froehlich Memorial), 1927
64 × 35
Gift of the Art and Manual Training Teachers of Newark, 1927 *27.1451*

4. **Cappelin and Company**, Italy
Bowl, 1927
3 ½ × 13
Purchase 1928 *28.1214*

5. **François Décorchemont**, France
Bowl with low relief decoration, 1928
6 ½ × 12 × 4
Purchase 1929 *29.1369*

6. **W. P. A. Glass Works**, United States
Vase with purple looping, 1943
16 × 4 ¾
Purchase 1943 *43.31*

7. **Maurice Heaton**, United States
Plate with stylized bird design, 1949
14 ½
Purchase 1950 *50.2079*

8. **Michael and Frances Higgins**, United States
Trapezoidal dish, 1951
11 ⅝ × 14 ½ × 1 ¼
Purchase 1952 *52.296*

9. **Tapio Wirkkala**, Finland
Leaf-form dish, 1955
Cast and carved glass, 16 ¼ × 5
Purchase 1956 John B. Morris Fund *56.105*

10. **Edvin Ohrstrom**, Sweden
Vase of "Ariel" glass with internal decoration, 1940-50
6 ¾ × 5
Gift of Miss Morna LaPierre, 1956
56.143

11. **Paolo Venini**, Italy
Bottle vase, *Notte*, 1958
13 ½ × 2 ½
Purchase 1958 *58.68*

12. **Louis Comfort Tiffany**, United States
Vase with internal decoration of poppies, 1906-12
6 ½ × 6
Gift of Mr. and Mrs. Ethan D. Alyea, 1966 *66.473*

13. **Roland Jahn**, United States
Vessel / sculpture of colorless glass, 1967
5 × 7 ½ × 5 ¾
Purchase 1968 Membership Endowment Fund *68.3*

14. **Paul Joseph Stankard**, United States
Lady Slipper Botanical, 1984
3 × 2 × 2
Purchase 1984 W. Clark Symington Bequest Fund *84.8*

15. **Dale Chihuly**, United States
Permanent Blue Macchia with Cadmium Orange Lip Wrap, 1986
17 × 20 × 27
Purchase 1988 The Members' Fund *88.90*

16. **Leonard DiNardo**, United States
Ain't No Time to Wonder Why, 1989
7 ¾ × 8 ¾
Purchase 1989, The Members' Fund *89.85*

17. **Toots Zynsky**, United States
Tierra del Fuego, 1989
5 × 11 × 7
Purchase 1989 Thomas L. Raymond Bequest Fund *89.5*

18. **Richard Marquis**, United States
Teapot Goblet #78, 1989
12 ½ × 3 ½
Purchase 1990 Thomas L. Raymond Bequest Fund *90.6*

19. **Glen Lukens**, United States
Slumped bowl / platter, orange and black, 1952-60
17 ½ × 2 ⅛
Purchase 1990 Estate of Clara Streissguth *90.240*

20. **Mark Peiser**, United States
Vase with internal decoration of large flowers, 1976
12 ½ × 8
Gift of Beverly and Herbert Paskow, 1991 *91.77*

21. **Fritz Dreisbach**, United States
Double Latticino Cup, 1978
7 ½ × 4 ½
Gift of Dr. and Mrs. Jerry Raphael, 1996 *96.23.5*

22. **Michael Glancy**, United States
Vase of carved green glass, 1975
5 × 3 × 3
Gift of Dr. and Mrs. Jerry Raphael, 1996 *96.23.6*

23. **Dominic Labino**, United States
Vase of amber glass, 1963
8 ¾ × 6 × 4 ½
Gift of Dr. and Mrs. Jerry Raphael, 1996 *96.23.9*

24. **Marvin Lipofsky**, United States
Vessel / sculpture of green glass, 1965
6 × 7 ¼ × 4
Gift of Dr. and Mrs. Jerry Raphael, 1996 *96.23.11*

25. **Thomas McGlauchlin**, United States
Bubble Vessel, 1983
10 ½ × 7 diameter
Gift of Dr. and Mrs. Jerry Raphael, 1996 *96.23.13*

26. **Joel Phillip Myers**, United States
Black and white vase, 1977
9 × 4 ¼
Gift of Dr. and Mrs. Jerry Raphael, 1996 *96.23.14*

27. **Fritz Dreisbach and Arthur Reed**, United States
Paperweight, 1972
3 ¼ × 4 × 4
Gift of Dr. and Mrs. Jerry Raphael, 1996 *96.23.16*

28. **James Tanner**, United States
Witch Ball Pitcher, 1972
9 ¼ × 5 ¼ × 5
Gift of Dr. and Mrs. Jerry Raphael, 1996 *96.23.18A-N*

29. **Stanislav Libensky and Jaroslava Brychtova**, Czech Republic
Cross Composition, 1986
32 × 24 × 8
Gift of Dena and Ralph Lowenbach, 2006 *2006.63*

COLLECTION OF DENA AND RALPH LOWENBACH
(in alphabetical order)

30. **Oben Abright**, United States
Loss Series No. 7, 2005
15 × 8 × 7

31. **Hank Murta Adams**, United States
Head with Monitor, 2003
20 × 12 × 9

32. **Rick Beck**, United States
Clear Reclining Scissors, 2005
17 × 36 × 5 ½

33. **Christina Bothwell**, United States
Little Friends, 2003
11 × 14 × 6

34. **William Carlson**, United States
Prägnanz, 1989
27 × 17 × 5

35. **Jose Chardiet**, United States
Wickendon Teapot, 2003
14 × 7 × 3

36. **Dale Chihuly**, United States
Two-Part Basket, 1979
larger basket: 11 × 9 × 10
smaller basket: 8 × 9 × 8

37. **Dale Chihuly**, United States
Cobalt Violet Deep Persian Set, 1993
15 × 31 × 16

38. **Dale Chihuly**, United States
Burning Red Macchia with Ash Lip Wrap, 2002
18 × 20 × 18

39. **Dale Chihuly**, United States
Golden Sulfur Persian Set, 2004
18 wide

40. **Dan Dailey**, United States
Poem Man, 1992
22 × 10

41. **Laura de Santillana**, Italy
Untitled, 2003
14 ½ × 17 ½ × 2 ½

42. **Miriam DiFiore**, Italy
Snail's Dream, 2003
27 × 17 × 12 ½

43. **Shane Fero**, United States
Anhinga and Babe, 1998
15 × 6 × 5

44. **Michael Glancy**, United States
Complex Convolution, 1997
9 × 12 × 12

45. **Stanislava Grebenickova**, Czech Republic
Night Sky, 1999
20 × 20 × 5

46. **Eric Hilton**, United States
Time's Source, 1996
22 × 16 × 7
metal support base: 15 × 16 × 12

47. **Sydney Hutter**, United States
Twisted Abstract Strip Vase, 1991
23 × 12

48. **Toshio Iezumi**, Japan
F.021203, 2003
7 × 13 × 12

49. **Kazumi Ikemoto**, Japan
Scene 0203, 2005
14½ × 15

50. **Richard Jolley**, United States
Endurance of Beauty, 1999
66 × 20

51. **Janet Kelman**, United States
Cobalt Seafan, 2002
11 × 23 × 17

52. **Vladimir Kopecky**, Czech Republic
Untitled, 1980
10½ × 26 × 2½

53. **Jon Kuhn**, United States
Pure Reason, 2003
15 × 12 × 6

54. **Karen LaMonte**, Czech Republic / United States
Gluttony, 1996
28 × 16

55. **John Lewis**, United States
Gold Triangle, 1996
34 × 71 × 16

56. **Stanislav Libensky, and Jaroslava Brychtova**, Czech Republic
Spaces VI, 1994-95
20 × 40 × 9 (not including base)

57. **Marvin Lipofsky**, United States
?IGS VI 1997-98 #4, 1997
14 × 16 × 16

58. **Harvey Littleton**, United States
Blue Folded Form, 1977
13 × 7 × 5

59. **Harvey Littleton**, United States
Ruby and Blue Linked Form, 1988
12 × 14

60. **Duncan McClellan**, United States
Cold Winter Night, 1998
17 × 13

61. **Thomas McGlaughlin**, United States
Irregular Spheres, 1985
20 × 11 × 11

62. **William Morris**, United States
Stonehenge Vessel, 1985
20 × 16 × 6

63. **William Morris**, United States
Petroglyph Vessel, 1989
18 × 19 × 5

64. **William Morris**, United States
Suspended Artifact, 1995
61 × 23 × 12 (includes base)

65. **William Morris**, United States
Medicine Jar: Crow on Corn with Grasshoppers, 2005
17 × 7

66. **Robert Palusky**, United States
Family Values – Staying Afloat, 1996
36 × 20 × 4

67. **Thomas Patti**, United States
Asahi Lumina with Clear, 1991
4 × 6 × 4

68. **Stephen Rolfe Powell**, United States
Ordered Chaotic Cleavage, 2002
34 × 19 × 12

69. **Asya Reznikov**, United States / Russia
Bound, 2002
28 × 7 × 6

70. **Davide Salvadore**, Italy
Untitled, 1995
21 × 12 × 5

71. **Charles Paul Savoie**, United States
Serafina Goblet, 2003
18 × 6

72. **Judith Schaechter**, United States
Rejects, 2000
29 × 36 × 6

73. **Mary Shaffer**, United States
Center Cube, 1992
34 × 11 × 9

74. **Jeff Spencer**, United States
Helping, 1997
11 × 17 × 5

75. **Lisabeth Sterling**, United States
Yes or No, 2001
14 × 10 × 3

76. **Lino Tagliapietra**, Italy / United States
Bilbao, 2001
26 × 13 × 7

77. **Bertil Vallien**, Sweden
The Artist, 1990
14 × 10 × 5

78. **Jörg Zimmerman**, Germany
Yellow Jr. II, 2001
10 × 14 × 13

COLLECTION OF THE
PRUDENTIAL INSURANCE
COMPANY OF AMERICA

79. **Dale Chihuly**, United States
Blue Venetian, 1988
20 × 13 × 13

BIBLIOGRAPHY

Fairbanks, Jonathan L., and Pat Warner, *Glass Today by American Studio Artists*. Boston: Museum of Fine Arts, 1997.

Johnson, Donald-Brian, and Leslie Piña, *Higgins, Adventures in Glass*. Atglen, PA: Schiffer Publishing Ltd, 1997.

Klein, Dan, *Glass, A Contemporary Art*. New York: Rizzoli, 1989.

Kohler, Lucartha, *Glass, an Artist's Medium*. Iola, WI: Krause Publications, 1998.

Labino, Dominick, *Visual Art in Glass*. Dubuque, IA: William C. Brown Company Publishers, 1968.

Layton, Peter, *Glass Art*. London and Seattle: A. & C. Black and University of Washington Press, 1996.

Lynn, Martha Drexler, *American Studio Glass 1960-1990*. New York and Manchester, VT: Hudson Hills Press, 2004.

Lynn, Martha Drexler, with Barry Shifman, *Masters of Contemporary Glass, Selections from the Glick Collection*. Indianapolis: Indianapolis Museum of Art and Indiana University Press, 1997.

Opie, Jennifer Hawkins, *Contemporary International Glass, 60 Artists in the V&A*. London: V&A Publications, 2004.

Phillips, Robert F., and Paul Smith, *American Glass Now*. Toledo and New York: Toledo Museum of Art and Museum of Contemporary Crafts, 1972.

Weeks, H. J., *Reflections on Glass*. Long Beach: Long Beach Museum of Art, 1971.